A CENTURY OF CAPRICIOUS COLLECTING

1 8 7 7 – 1 9 7 0

From The Gallery In Science Hall
To The Elvehjem Museum Of Art

By James Watrous

Foreword

Since the Elvehjem first opened in 1970, its various activities: the development of the permanent collections, the mounting of numerous exhibitions, changes in the direction and staffing, the creation and expansion of public and private support structures, etc., have been faithfully and carefully chronicled by the annual *Bulletin*. This publication, wisely instituted by the Museum's first director, Millard F. Rogers, Jr., provides an on-going record of the Museum's history. However, the sum of all the issues of the *Bulletin* does not give the complete picture. Like any major institution, the Elvehjem had a long and complicated prehistory involving personal dedication, prodigious efforts, and the unfaltering belief that the visual arts have a significant role to play in the educational mission of the University.

The present volume, which constitutes a preamble to the information published serially in the museum Bulletins, represents the first attempt to record the Elvehjem's genesis and assures recognition of the numerous individuals who so effectively brought the Museum into being.

Of all those who unselfishly contributed to the realization of the dream, Professor, now Emeritus Professor, James Watrous was the most dedicated. It was his understanding of the potential contribution of original works of art to higher education, together with his unflagging patience and personal commitment to the idea of preserving the University's then existing collections that led to the creation of a significant university museum.

With this volume Professor Watrous has provided us with a richly detailed account of those events in which he himself played such an important role. We are grateful to him for this monograph which undoubtedly will serve the Museum staff, alumni and the University at large as a history and a record, a lesson and a stimulus for future achievements.

Russell Panczenko
Director

1877–1970 From The Gallery In Science Hall To The Elvehjem Museum Of Art*

The completion of the Elvehjem Museum of Art was celebrated in September 1970. Nearly a century before, in 1877, a University Art Gallery had been built in Wisconsin's first, and ill-fated, Science Hall.[1] The central section of the fourth floor was a room, forty-three by forty-six feet, described as a ". . . fine art gallery, with large sky-light . . . one of the adornments of the new Science Hall." (Fig. 1) *The Wisconsin State Journal* reported that "the valuable works in that gallery included the celebrated Thomas Moran paintings of Lakes Mendota and Monona, which attracted so much attention at the Centennial Exposition" in Philadelphia, 1876, works which cost an astonishing $1,000 each.[2]

Moran, an acclaimed American landscape painter, had been induced to come to Madison in 1876 by Mrs. Joseph G. Thorpe, Chairman of the centennial Women's Executive Committee for Wisconsin.[3] With his wife Mary Nimmo Moran, a gifted etcher, he spent some pleasant days sailing the lakes and sketching the surrounding hills.[4] The studies led to landscapes more faithful to the region than were the allegorical images "The Four Lakes of Madison,"[5] composed by Henry Wadsworth Longfellow for Wisconsin's display in the Women's Pavilion. Longfellow wrote the verses at the request of his daughter's mother-in-law, Mrs. Thorpe.

Moran's canvases, completed in late 1876, were first exhibited in Memorial Hall at Philadelphia. By early 1877, there must have been some embarrassment in Wisconsin because no payment had been made to the artist. Mrs. Alexander Mitchell, wife of a Milwaukee financier, offered to contribute $1,000 for *Sunset, Lake Mendota*—if the State Legislature appropriated an equal sum for the painting of Lake Monona.

When the legislature ignored the matching offer, a campaign for private contributions was proposed. Governor Harrison Ludington initiated the drive with a personal donation of $250. Soon thereafter, Mrs. Thorpe prevailed upon her son-in-law, the internationally acclaimed Norwegian violinist, Ole Bull, to give a benefit concert. Tickets for the event were one dollar each. Over a thousand people crowded into the Congrega-tional Church on the night of February 16, 1877 and the *Madison Daily Democrat* hailed Bull's performance with a boldface caption, "OUR PAGANINI."[6] The *Madison Patriot* confirmed that "The event was a financial as well as musical success, and the large fund thus raised will, through Ole Bull's generosity be tendered to the Art Gallery of the State University."[7]

For seven years the University was blessed with a gallery and the beginnings of an art collection. Then, on the night of December 1, 1884, "old" Science Hall was gutted by fire. (Fig. 2) ". . . the fourth floor contained the valuable museum . . . devoted to the art collection, which while yet limited and incomplete, contained many fine paintings and gave promise of developing into an institution of which the university might well feel proud."[8] The *Wisconsin State Journal* noted that only one vestige of the art collection survived. "Mrs. E. R. [Eva] Curtiss has made a very superior copy of Moran's fine painting of Lake Monona. . . . It will be doubly interesting and valuable, now that the great original is in ashes.[9] (Fig. 3)

After the conflagration, there were no initiatives to build a new University Gallery or to revive interest in an art collection. And, in 1909, when a bronze replica of Adolph Weinman's *Abraham Lincoln* became a campus landmark on Bascom Hill, there was no claim of a new beginning of an art collection.[10] Indeed, it would be three decades after the Science Hall fire before happenstance led to the donations of sixty-seven paintings which Charles R. Crane of Chicago and Colonel William C. Brumder of Milwaukee purchased from Professor Paul S. Reinsch.

Reinsch, a political scientist, served as a Roosevelt Exchange Professor at the universities of Berlin and Leipzig in 1911–1912. While abroad, he acquired over 150 European works of art—mostly by Dutch, Flemish, and German artists with a sprinkling of paintings by Italian, French,

* In 1977 the name of the Elvehjem Art Center was changed to the Elvehjem Museum of Art in order to characterize more appropriately the museum collections and programs.

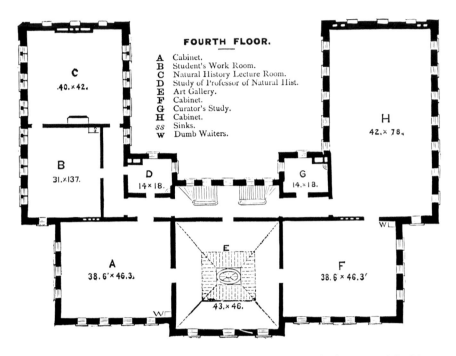

FOURTH FLOOR.

A Cabinet.
B Student's Work Room.
C Natural History Lecture Room.
D Study of Professor of Natural Hist.
E Art Gallery.
F Cabinet.
G Curator's Study.
H Cabinet.
ss Sinks.
w Dumb Waiters.

Fig. 1 Plan of the fourth floor of "old" Science Hall showing the location of the University's first art gallery. *Catalogue of the University of Wisconsin 1875–1876.*

Fig. 2 "Old" Science Hall after the fire on 1 December, 1884. State Historical Society of Wisconsin.

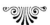

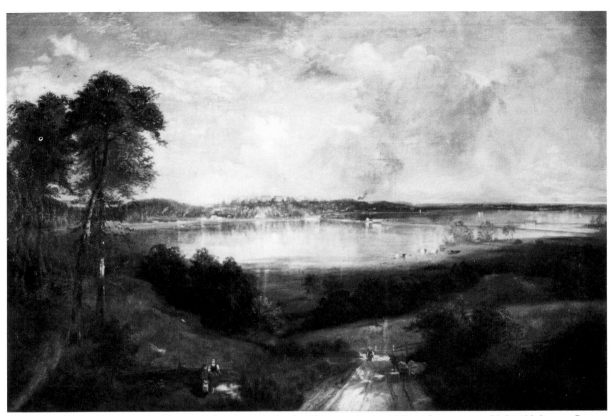

Fig. 3 Mrs. E. R. Curtiss, *Lake Monona* (after the painting by Thomas Moran), 1884, oil on canvas, 89.0×132.2 cm., Courtesy of Bowden Curtiss, Darlington, Wisconsin. The landscape was described as " . . . a view of the city from Wingra Mounds . . . towering up to four times their true proportions." *Madison Past and Present, 1852–1902* (Madison, 1902), 49.

Fig. 4 Frans Jansz Post, *Village of Olinda, Brazil*, ca. 1660, oil on canvas, 82.6×130.7 cm., Gift of Charles R. Crane.

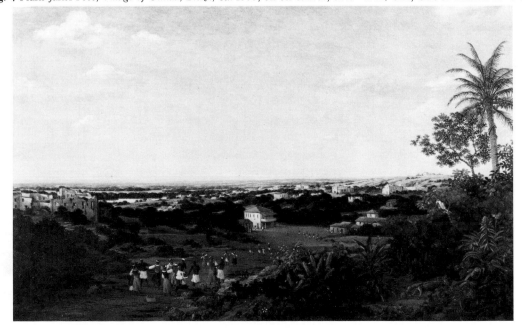

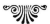

Spanish and British masters. In order to finance his art collecting, Reinsch planned to sell approximately half of his purchases to friends in Milwaukee and elsewhere.[11] (Fig. 4)

The collection was first shown publicly in September and October 1912, when the Madison Art Association sponsored an exhibition at the State Historical Library.[12] Having no place to store such a large number of art works, Reinsch turned to the University for help following the exhibition. In November, the Regents approved a recommendation by President Charles Van Hise that the Reinsch paintings be ". . . placed in Lathrop Hall for a period of one year . . . with no expense to the Regents except for the payment of the fire insurance. . . ."[13]

In fact, the lending of space lasted less than a year. In August 1913, upon returning to Madison from a walking trip in central Wisconsin, Reinsch learned that he had been appointed minister to China by President Woodrow Wilson.[14] He acted quickly to reduce his collection. On October 8, the Regents accepted sixty of the Reinsch paintings as a donation from Charles Crane, President of the Crane Plumbing Company and seven others from Colonel Brumder, alumnus, banker, and publisher of the *Germania-Herold* in Milwaukee.[15] The gifts prompted the *Wisconsin State Journal* to speculate that "The donation of this collection to the university marks the beginning of an art movement in Wisconsin and looks forward to the establishment of the state museum on the university grounds."[16] It took fifty years for this prediction to be fulfilled.

In the interim, the Crane and Brumder collections had to be housed somewhere and the Regents made a sequence of space assignments that were bothersome to university departments. In late 1913, the paintings were hung in one of two rooms occupied by the Department of Home Economics on the fourth floor of Lathrop Hall. In January 1914, when Home Economics moved

to the new Extension Building, the Regents assigned the same two rooms in Lathrop to Women's Physical Education with directions that the department should not interfere with the use of one of the rooms for the hanging of the art collection and the activities of the women's literary societies.[17] The awkwardness of these accommodations became more acute in December 1914, when the Regents directed that the paintings should be moved to the recently completed Wisconsin High School building.[18] The decision compounded the careless treatment of the art and, in time, led to the haphazard dispersal of the paintings around the campus. Furthermore, between 1913 and 1919, Reinsch added to the disorder by losing, and removing, paintings that Crane had purchased for the University.[19] For over a half century thereafter, the art works disappeared from view or suffered neglect and vandalism. (Figs. 5a, 5b)

Unmindful of its careless stewardship and indifferent to the need for a museum, the university administration continued to accept donations of art. In 1923, the children and university friends of Henry Reinhardt, a native of Milwaukee and a New York art dealer, gave a Renaissance altarpiece in his memory. The *Adoration of the Shepherds* by Giorgio Vasari was so large that only a grand stair landing in the State Historical Library was able to accommodate it.[20] (Fig. 6)

Meanwhile, two organizations sponsored changing exhibitions on or near the campus. From 1914 to 1932, the Madison Art Association was granted exclusive use of a gallery on the top floor (north wing) of the State Historical Library. Exhibitions by local artists and Madison school children, or shows imported to the city, were presented in the gallery until the Historical Society reclaimed the space. Afterward, the Art Association continued its exhibition program, but far from the campus.[21]

In 1928, when the Memorial Union Building was nearing completion, Porter Butts, Director

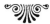

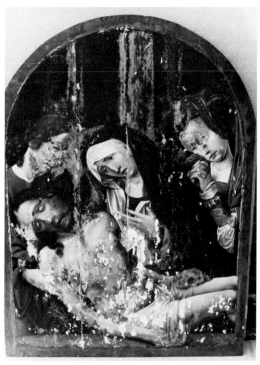

Fig. 5a Colijn de Coter, *Lamentation,*
central panel before restoration.

Fig. 5b Colijn de Coter, *Lamentation,* ca. 1515–1525, oil on panel, 105.1×74.9 cm. (central panel), 102.9×29.2 cm. (left
wing), 103.2×29.5 cm. (right wing), Gift of Charles R. Crane.

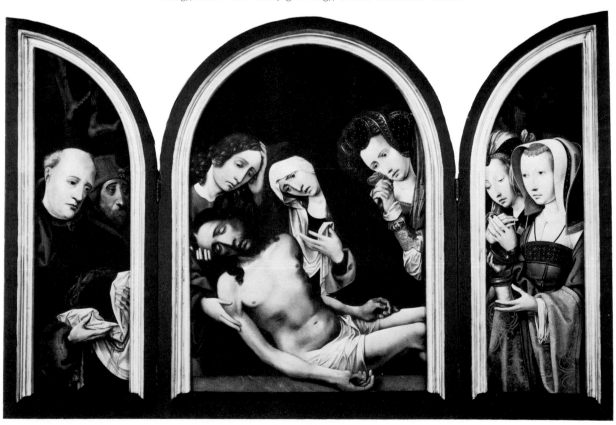

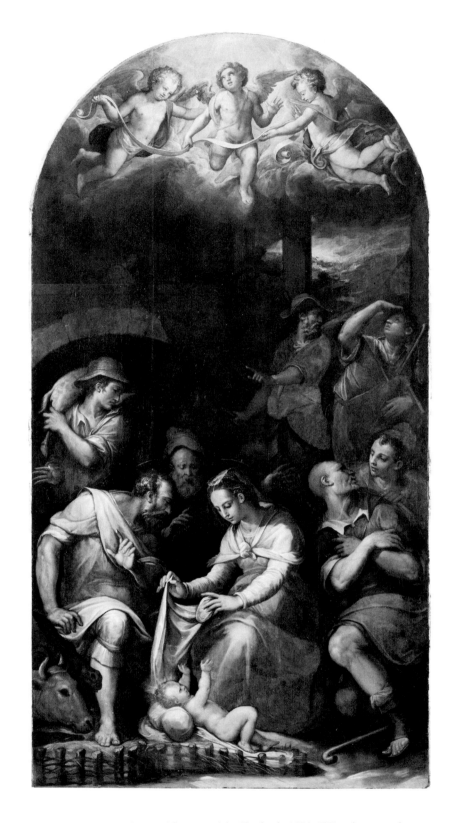

Fig. 6 Giorgio Vasari, *Adoration of the Shepherds*, 1570–1571, oil on panel, 334.0×175.2 cm., Gift of Alumni and Heirs of Henry Reinhardt.

of the Wisconsin Union, had the foresight to change an "Assembly Room" on the main floor into the Wisconsin Union Gallery. (Fig. 7) During the next four decades, it offered the principal program of changing exhibitions on the campus. Gradually, from those exhibitions, the Wisconsin Union acquired art works for its walls and a student loan collection.[22]

In contrast to the highly visible exhibitions at the Union—especially the annual Wisconsin Salon of Art, initiated in 1934—the Crane and Brumder paintings were largely ignored and rarely seen. A search for the scattered paintings in the late thirties led to a typed memorandum that languished in the files of the Department of Art History. On April 26, 1937 Laurence Schmeckebier, an assistant professor of art history, composed a "Memorandum on the Paintings of the Former Reinsch Collection Now Owned by the University." He had found forty-eight of the sixty-seven works. Some were defaced by scratches, holes, and graffiti. Others hung over radiators or under steam pipes, and paintings and empty frames were found amidst refuse in janitors' closets. Schmeckebier wrote ". . . that the paintings exist today in a deplorable condition due to improper hanging, lack of technical preservation, and plain vandalism . . ." and that they should be ". . . removed to some temporary storage place to prevent their theft and further wanton destruction."[23]

In 1938, misgivings about stewardship were raised again when a new gift was accepted by the University. Joseph E. Davies, an alumnus and Ambassador to the Soviet Union, had written in March, 1937, to Governor Philip F. La Follette about his purchase of Russian paintings. "The thought had occurred to my mind that it might be interesting for the University of Wisconsin to have this collection; and I have considered the gift of pictures."[24] On May 20, Governor La Follette and Clarence A. Dykstra, President of the University, announced simultaneously the acceptance of ninety-six paintings of Russian life and landscape.

The following February, however, Davies wrote in dismay to Dykstra. "I was very much disap-

pointed . . . that there was no suitable room for the proper hanging of the pictures, or that arrangements would be made by the time the pictures were delivered."[25] Despite his unhappiness, Davies informed Dykstra that he had purchased some religious icons from the Soviet government, and that they might be another gift, if properly housed. "However, I would not be doing justice to the gift unless I were to place them with some institution that would make suitable provision for their exhibition and care."[26]

Nonetheless, in June 1938, when an exhibition of the Davies Collection opened in the Wisconsin Union Gallery, the gift to the University included twenty-three icons as well as the landscape and genre paintings.[27] The exhibition, scheduled to coincide with Alumni Week and Commencement, prompted Dykstra to write Davies that the paintings were "magnificent" and that "The icons are on a background of dark velvet and appear to great advantage."[28] (Fig. 8)

The President's letter, however, disregarded the concerns of the donor about permanent display and care for the works of art. When the exhibition closed in mid–July, few knew that the next stop was Rindy's Madison Fireproof Warehouse. The paintings and icons remained there until May 1939, when they were trucked to a room in the basement of Bascom Hall vacated by the University Theater whose equipment was moved to the recently completed Wisconsin Union Theater.[29] This concrete bin was reassigned as the store room for the Davies gift along with a number of the Crane and Brumder paintings that Schmeckebier gathered from various campus buildings.

The Regents, upon accepting the Davies paintings, directed that the chair of the Department of Art History should be, *ex officio*, Curator of university art collections. Professor Oskar F. L. Hagen, then Chairman, accepted the custodianship, but without enthusiasm.[30] Although Hagen was Curator until 1947, he was spared the stewardship after 1939 when it was undertaken unofficially by the author, then a new instructor in the department.

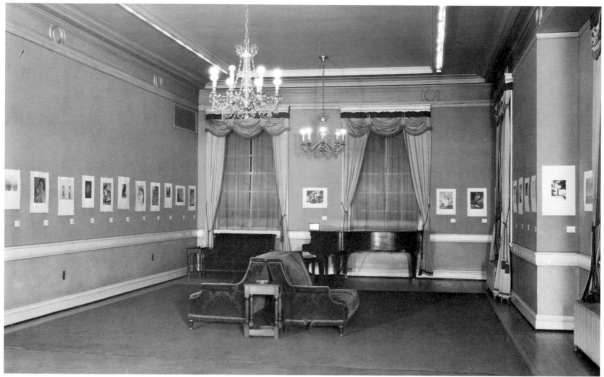

Fig. 7 Wisconsin Union Gallery, ca. 1928, Courtesy of the Wisconsin Union.

Fig. 8 Greek, *Triptych with Great Deësis and Dodekaorton*, ca. 1534–1549, tempera on panel, 127.0×106.2 cm. (central panel), 119.5×49.5 cm. (left wing), 119.0×49.5 cm. (right wing), Gift of Joseph E. Davies.

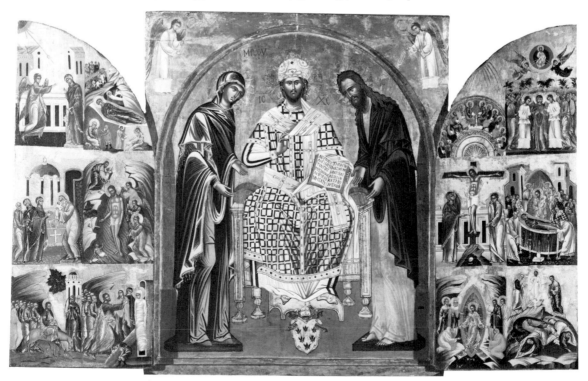

In 1939, soon after the fall semester began, the author and Robert Hubbard, a graduate Fellow learned, quite by accident, that art works were stored in the basement of Bascom Hall.[31] Room "E"—the space vacated by the University Theater—was dimly lit, and stifling hot. Since there were no racks for hanging, the paintings were stacked in random piles against the concrete walls. Because the room was too small, the largest paintings—still crated—lined the basement corridors. In dismay, the author wrote to President Dykstra about the lack of care of the paintings and the need for an art gallery, not knowing that similar concerns had been stated shortly before by Professor Schmeckebier and Joseph E. Davies. Dykstra did not respond. Still the chance visit to the basement of Bascom Hall was the beginning of years of advocacy for an art museum.

During the next decade, despite pleas for an annual conservation budget by the art historians, only small sums were sporadically granted.[32] And an apathetic attitude on "The Hill" appeared again in 1946. In October, the University of Wisconsin Foundation, which had been established the year before, published *The Proposed New Mall*.[33] A brochure, with renderings, set forth a plan to redesign the Lower Campus Area from Johnson Street to Lake Mendota. (Fig. 9) Several buildings were to be financed with gift funds received by the Foundation. One complex (Number "7") was described as an "Art Institute and Museum of Science and History." The proposal prompted the Graduate School to call a meeting to discuss a museum building. Led by J. Homer Herriot, Associate Dean, a score of faculty representatives from the science departments and art history met in Science Hall. Those present, with one exception, stated a preference to exhibit the collections of minerals, plants, animals, and other objects near various departmental headquarters. Since the only support for a museum came from the representative of the curator of university art collections, the proposal foundered.[34]

At the opposite end of the campus, the College of Agriculture had built a studio expressly for the "regionalist" painter, John Steuart Curry. There he had painted, serving the Rural Art Program as Artist-in-Residence, from 1936 until his death in 1946.[35] To commemorate Curry, the Regents made a rare appropriation for art—$2,000 to acquire a painting by the artist. A committee comprised of faculty members and Madison friends of the painter reviewed works in anticipation of purchasing a major painting.[36] Hopes were dashed when the artist's widow raised the prices of the oils far beyond the sum authorized by the Regents. The committee unenthusiastically proposed the purchase of several very minor pieces including a lithograph, two color sketches, two drawings, and a more worthy work, *The Plainsman*—a study for a similar figure in the murals of the Kansas State Capitol. (Fig. 10) The works, delivered in 1948, were promptly deposited in the basement of Bascom Hall.

Modest progress of another kind began in 1948. Mark H. Ingraham, Dean of the College of Letters and Science, was the first major administrator to accept the University's obligation to care for its art collections. Consequently, he not only granted monetary support, but also approved a proposal to appoint graduate students as curatorial assistants.[37] The first recruit was Constance Ford (Dowling), a graduate of Oberlin College.[38] Lured from the Metropolitan Museum of Art by the opportunity to study at Wisconsin, she initiated a museum cataloguing system, monitored the condition of each object, organized the photographing and record-keeping of the collection, and sought out paintings previously overlooked in university buildings.

In 1950, when the Office of the University Registrar began to keep records on IBM punch cards, space was needed for the machines and air conditioning for their efficient functioning. An area in the basement of Bascom Hall, including the art storage Room "E," was requested. A "swap" was then proposed. It was agreed that the paintings could be stored in a nearby room if the air conditioning for the IBM machines were piped into the new art storage space.[39] At that time, Dean Ingraham furnished monies to build

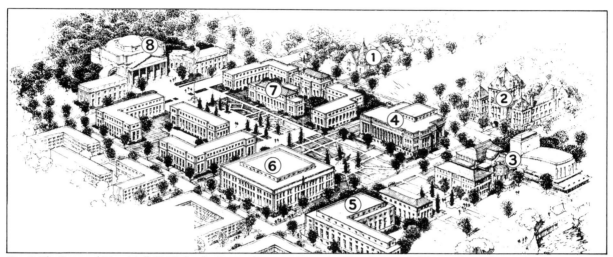

Fig. 9 *The Proposed New Mall* (1946) for the Lower Campus Area. An "Art Institute" (7) was planned near the present location of the Elvehjem Museum of Art.

Fig. 10 John Steuart Curry, *The Plainsman*,
1940, charcoal and red chalk, 77.5×57.2 cm., University purchase.

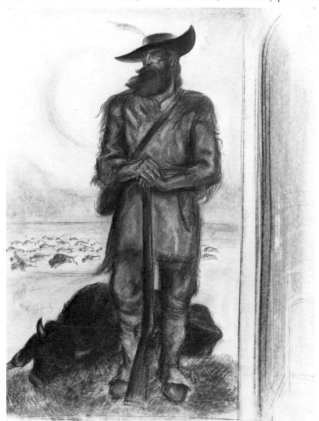

moveable racks for hanging paintings, and cabinets for storing prints and drawings. (Fig. 11)

By the 1950s, it was painfully obvious that the University needed a museum for the art it was acquiring rather haphazardly.[40] Moreover, departments were increasing the requests for the University to improve collections in areas of art that were related to academic programs. An example was the fine art of printmaking.

The history of printmaking in the Western World became an attractive academic offering with the arrival, in 1937, of Wolfgang Stechow, a distinguished German art historian from the University of Göttingen. After 1940, when Stechow left for Oberlin College, the author was encouraged to offer two additional courses in the history of prints. Furthermore, studio courses in creative printmaking became more popular when Alfred Sessler, Dean Meeker and Warrington Colescott joined the Department of Art between 1946 and 1949.[41]

In 1950, Dean Ingraham recognizing this important development, lent his support to the collecting of original prints. From time to time

thereafter, he provided funds to purchase the prints that would eventually—along with gifts in kind—constitute one of the Elvehjem's strengths. Among the first purchases were prints by twentieth-century artists: Max Beckmann, Ernst Barlach, George Grosz, Odilon Redon, Henri Matisse, José Clemente Orozco, and George Bellows. (Fig. 12)

The interest in building a collection of original prints began to be known in other quarters of the campus. Thus, in 1952, Gilbert Doane, Director of the University Library, encouraged John C. Hawley to give 122 prints in memory of his wife, Mary Oakley Hawley a member of the Class of 1893.[42] Many of them were etchings by twentieth-century Americans such as Ernest Roth, George Charles Aid, David Shaw MacLaughlin, and nineteenth-century British printmakers, including Francis Seymour Haden, who was represented by mezzotints, dry points and etchings. (Fig. 13)

Following the failure of Hagenah's proposed "New Mall" with its "Art Institute," the need for an art museum was mentioned only sporadi-

Fig. 11 Art Storage, room "E," in the basement of Bascom Hall, after 1950 and the installation of moveable racks for paintings.

Photo: Gary Schulz

Fig. 12. Ernst Barlach, *Christ on the Mt. of Olives,* 1919, woodcut, 20.3×25.4 cm., University purchase.

Fig. 13 Francis Seymour Haden, *Egham Lock,* 1859, etching, 15.2×22.6 cm., Gift of John C. Hawley.

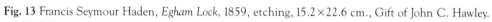

cally. As part of the celebration of the University's centennial in 1949, an exhibition of old-master paintings from the Metropolitan Museum of Art was presented in the Wisconsin Union Gallery. Professor William Kiekofer (Economics), Chairman of the Centennial Committee, praised the exhibition and declared that there should be a fine arts building ". . . to house all the art treasures of the University, present and prospective. . . ."[43]

By happenstance, the lack of an art gallery was cited again in 1952 when the Regents accepted thirty works by amateur painters that had been shown around the state in one or another Rural Art Exhibition. Some of the paintings were donated by *The Wisconsin Agriculturist* and some by *Successful Farming*. Others were purchased with monies from a John Steuart Curry Memorial Fund. When Wilbur Renk, a Regent, asked President E. B. Fred where the University would exhibit the paintings, Mr. Fred replied that they would probably be stored with other art works in the basement of Bascom Hall, adding that the university needed a building to display its growing collection. [44]

The President's response was not an indication that the administration fully understood how the resources of such an institution would enrich the academic and cultural life of the University. During the middle years of the 1950s there was no hint that those perceptions had changed. President Fred suggested several times that the University might share space and programs with the Madison Art Association, although the latter had no galleries, and neither programs would have flourished with divided authority and different missions. On another occasion, a member of the administration advised the author that one day an academic building would be vacated whose ground floor might be converted into exhibition space.

Equally unpalatable was a proposal made by Roger Kirchoff, the State Architect. In September 1956, the Regents approved the remodeling, with additions, of Washburn Observatory in order to convert it into an Alumni House. Opposition quickly developed to changing the historic landmark and building a contiguous parking lot.

One of the early opponents was Kirchoff who failed to enlist the author in a plan to convince the administration that Washburn Observatory was more suitable as an art gallery. It was a proposal without merit except as a ploy to forestall the reconstruction of the building as an Alumni House.[45] (Fig. 14)

Meanwhile, the new Memorial Library had been dedicated in February, 1954. Louis Kaplan, then Associate Director, had the walls of a fourth floor room covered with monks cloth. The space served as a temporary gallery from the mid-fifties to the mid-sixties. There was no formal schedule of exhibitions, although two or three were presented randomly each year.[46] Most of the faculty members of the Department of Art, and a few non-University artists, held one-man shows there at their own expense. Occasionally, exhibitions of other kinds were presented. In 1958, the Madison Art Association—still without a "home"—scheduled two shows that were touring the country, and during the decade the Department of Art History sponsored two exhibitions.[47] The opportunities to exhibit ended in 1965, however, when the gallery space was converted into a photo-copying center.

One of the exhibitions at the Memorial Library was comprised of paintings and prints from the university collections, supplemented with works lent by the Knoedler Gallery of New York. Among the paintings on loan were John Sloan's *Spring, Madison Square* (Fig. 15) and Eugene Berman's *Ischia Nocturne*. The two oils were purchased for the University by the Humanistic Foundation, which was soon reimbursed from the estate of Ruth Wallerstein.[48] In 1958, Wallerstein, a professor of English literature, had died after a car crash in England. Her will provided funds for the purchase of a painting or paintings. It also directed that the art should hang in a women's residence hall until the University built an art gallery for its permanent collections. The stipulation created anxiety for over a decade because *Spring, Madison Square* hanging as it did in the parlor of Chadbourne Hall, was visible to anyone walking along Park Street—and therefore, an easy target for theft or vandalism.

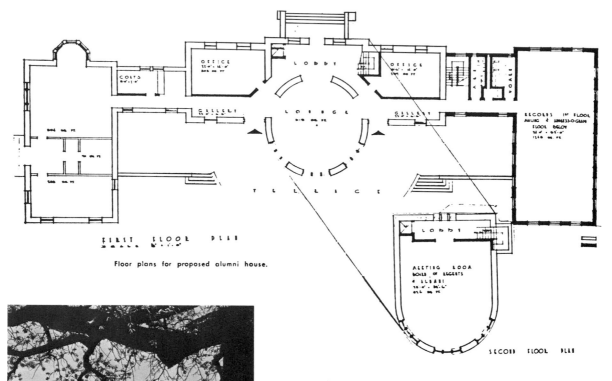

Floor plans for proposed alumni house.

FIRST FLOOR PLAN

SECOND FLOOR PLAN

Fig. 14 Schematic drawing for converting Washburn Observatory into an Alumni House. *Wisconsin Alumnus* 57.13 (15 May, 1956): 14.

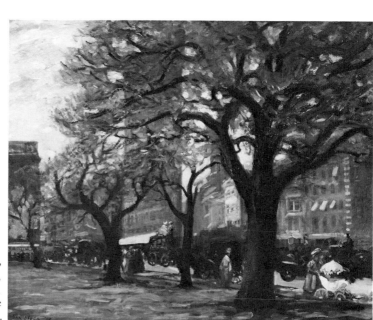

Fig. 15 John Sloan,
Spring, Madison Square, 1905,
oil on canvas, 74.9×90.2 cm.,
Ruth Wallerstein Fund purchase
(through the Humanistic Foundation Fund).

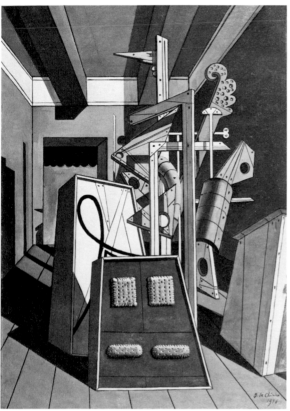

Fig. 16 Giorgio de Chirico, *Metaphysical Interior with Biscuits*, 1916, oil on canvas, 94.3×66.4 cm., Gift of Nathan Cummings.

Fig. 17 Jan Gossaert (Mabuse), *Christ at Rest*, 1527, oil on panel, 24.8×18.9 cm., Gift of Mr. and Mrs. Marc B. Rojtman.

Other gifts were nearly as vulnerable during those years. In 1957, *Metaphysical Interior with Biscuits* by the surrealist artist, Giorgio de Chirico, was given by Nathan Cummings, a Chicago financier.[49] (Fig. 16) For a decade the painting hung above the study tables in the Art History Reading Room (175 Bascom Hall). Also in 1957, Mr. and Mrs. Marc B. Rojtman of Milwaukee donated nine Netherlandish and Italian paintings, including *Christ at Rest* by the sixteenth-century Flemish master Jan Gossaert (Mabuse).[50] (Fig. 17) They hung for a dozen years in the blue lounge of the Wisconsin Center building. The greatest embarrassment, however, was the consignment of other treasures to the Bascom basement storage room.

After twenty years of pleading for an art gallery, the first promise of financial support came from Mark Ingraham who, as Dean, was the *ex officio* committee member of the Humanistic Foundation. In 1957, Ingraham assured the author, then the faculty chairman of the Foundation committee, that whenever the University launched a campaign to fund a gallery, he would urge a grant of $100,000. His pledge was heartening, although inconvertible as long as there was reluctance on "Bascom Hill" to seek private subventions for a building.

Also in 1957, two prominent alumni, George I. Haight and Howard Potter, volunteered to target an earlier benefactor. They reasoned that their old friend, Joseph E. Davies, and his heiress

wife Marjorie Meriwether Post Hutton Davies, were likely donors of a museum. Davies was to join his fellow alumni for a reunion in Chicago and, the following day, Haight would escort him by train to Madison.

The visit required that the Russian paintings be carefully checked and Room "E" in Bascom Hall well groomed. A model of a museum was placed conspicuously on a pedestal in the center of the storage area. The author and Arnold Lewis, Curatorial Assistant,[51] had hastily constructed it out of plywood and cardboard, painted and etched its walls to feign brick, and surrounded the "museum" with groves of sponge rubber trees and lawns of green sand. It was no more than an ephemeral "prop" created expressly to impress the visitor.

The Art History Reading Room was also made ready for a viewing of the several Russian icons that had been installed in cases atop its bookshelves. Word of the visitor's arrival at President Fred's office was relayed to the Department of Art History. It was time to ask the students to pick up their notes and leave the room to the presidential party.

Mr. Davies, Mr. Vogel, a factotum, and Mr. Haight were escorted by Mr. Fred and several associates to the Reading Room. The dozen or so paintings from the Davies and Crane collections were viewed quickly by everyone but Vogel who questioned their physical condition.

Then the group descended to the basement of Bascom where Lewis was posted to unlock the doors of the storage room. When all were inside, Mr. Davies reminisced about his ambassadorship in Moscow. When he inquired about one or another painting, the appropriate rack was drawn out for his viewing. This led him to relate his adventures as a collector and the amount of gold he had paid the Soviets for a landscape, history painting or icon. As the monologue continued, Haight grew impatient, pounded his fist on the model, and shouted at "Joe" to look at the "museum." Davies, however, artfully ignored every sally of his hosts, making it clear that he no longer could be courted as a benefactor. After all, he had received an honorary Doctor of Laws

in 1941, and his likeness, painted full length by the society portraitist Frank O. Salisbury, was already slated to hang in the Law School![52]

During the thirteen years of his presidency, Mr. Fred had asked repeatedly whether the University owned art works worthy of a gallery or museum. By 1957, the collection had grown to over 500 paintings, sculptures, prints, and drawings, and the President could be assured that many of them were of museum quality. Moreover, he was reminded at every opportunity that a gallery or museum for the permanent collections would foster additional donations.

As Mr. Fred's presidency neared its end, he shed his reluctance to endorse an art gallery. In February 1958, at the meeting of the Regents when Conrad Elvehjem was named as his successor, Mr. Fred observed: "In my judgment, there is no other building which could be given by private generosity that would more enhance the cultural influence of the University than an art center and gallery."[53]

Shortly before the Regents' meeting, the President had agreed to the creation of an architectural model of an "art center." Leo Jakobson, the new campus planner, designed a honeycomb structure—a cluster of hexagonal spaces to which new modules could be added as the need for more galleries and programs developed. (Fig. 18) The model was to be exhibited at the dedication of the Wisconsin Center, the first major building project of the University of Wisconsin Foundation. Though it arrived too late for the celebration on April 11, 1958, it was displayed on every appropriate occasion during the next four years.[54]

Neither the statement that President Fred had made to the Regents in February nor his concurrence in the preparation of an "art center" model, placed the new president, Conrad Elvehjem under any obligation when he took office on July 1. Nonetheless, additional support for such a building soon emerged. At the first meeting of his Administrative Committee, which was comprised of Deans and other major officers, Elvehjem requested a priority list of projects for which gift funds should be raised by the

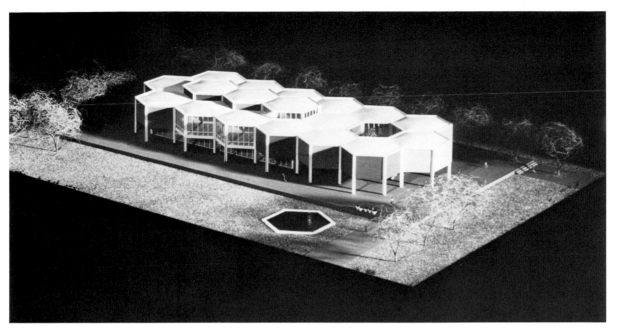

Fig. 18 Leo Jakobson, *Schematic Model for an Art Center*, 1958.

Fig. 19 Rembrandt van Rijn, *St. Jerome in an Italian Landscape*, ca. 1653, etching, 26.2×21.1 cm., Humanistic Foundation Fund purchase.

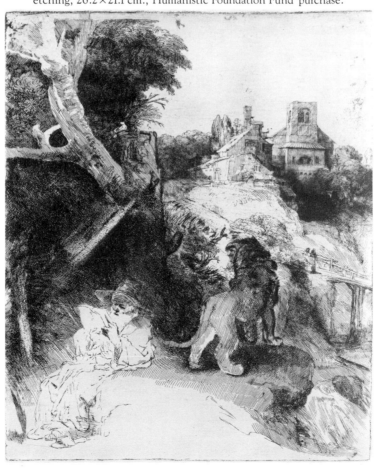

Foundation.[55] The recommendations—after university-wide consultations with the four Faculty Divisional Committees and the University Committee—were to be reported to the President by October 15. The responses placed an art center and galleries at the top of a priority list. Support from the College of Letters and Science was expected. But similar recommendations by the College of Engineering, the School of Education, the School of Pharmacy, and the Office of the Vice-President of Business and Finance were surprising. Elvehjem accepted the Administrative Committee's advice and, in league with the University of Wisconsin Foundation and alumni, fostered the search for funds from individuals and foundations.

The many earnest efforts to find benefactors during the next four years failed. Nonetheless, the growing enthusiasm for a museum encouraged donations and purchases of art. The Humanistic Foundation continued to grant monies for prints. In 1960, several works by contemporary American artists were purchased including woodcuts, etchings, and lithographs by Leonard Baskin, Mauricio Lasansky, Gabor Peterdi, and Ben Shahn. The following year, significant prints were acquired, notably Dürer's engraving, *Two Angels with the Sudarium with the Face of Christ,* and an etching by Rembrandt, *St. Jerome in an Italian Landscape.* (Fig. 19) However, the most important prospect during 1960–1961 was a gift of paintings and sculptures from the Kress Collection.

Fig. 20 Benedetto da Maiano, *Madonna and Child,* ca. 1491–1495, marble, 68.0 cm. Dia., Gift of the Samuel H. Kress Foundation.

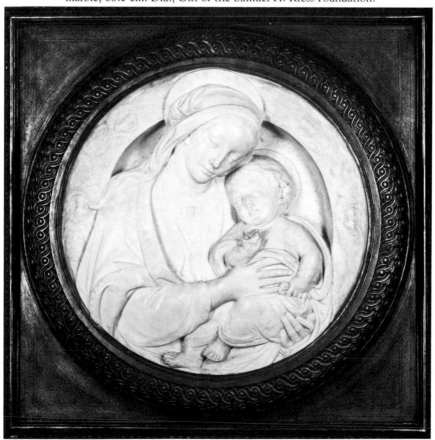

The Samuel H. Kress Foundation had, for many years, been a generous benefactor to the National Gallery of Art in Washington. In the fifties, the trustees began a program of donating works of art to other museums, including some on college campuses. Mr. Philip D. Reed, an alumnus and board member of the University of Wisconsin Foundation, suggested to Kress officers that the University might be a deserving recipient of Kress bounty. Soon thereafter, President Elvehjem received an invitation to discuss a possible gift.

The author was sent to New York as the representative of the University. At the Kress Foundation offices he met with the Art Director, Mr. Guy Emerson, and the Assistant Director, Ms. Mary M. Davis. He informed them of the University's growing commitment to the building of an art museum. But, unexpectedly, they responded with skepticism, arguing that Wisconsin had little else than a College of Agriculture and a College of Engineering. The misconception demanded immediate correction, and prompted a recitation of the University's accomplishments in many scholarly fields. Apparently, the impromptu discourse was persuasive because, after a luncheon, the records and photographs of the unassigned art in the Kress Collection were delivered to the conference room for review.

Several months later, the author returned to the Kress Foundation for a detailed discussion of the gifts. He requested that David Loshak, an assistant professor of art history, join him in the selection process. The two visitors also traveled to the Pocono Mountains where the Kress Foundation Conservation Center was located. There, Mr. Mario Modestini, Conservator, showed them the actual pieces that were tentatively designated for Wisconsin.

In 1961, the Kress Foundation donated twelve paintings and two sculptures. The most coveted was the marble tondo of a *Madonna and Child* by the Italian Renaissance sculptor, Benedetto da Maiano. (Fig. 20) The gifts were first exhibited at the Wisconsin Union Gallery during October and November. Afterward, interspersed with some of the Rojtman paintings, they hung in lounges of the Wisconsin Center building until the Elvehjem Museum of Art opened nine years later.[56]

Thomas Evans Brittingham was the donor of a trust fund that, for years, had provided support for scientific research, unusual scholarly and creative initiatives, and a miscellany of University-related projects. On December 20, 1961 Mr. Fred placed a long distance call to Wilmington, Delaware, in order to talk with Mrs. Thomas E. (Peg) Brittingham, II, and her sons, Baird and Thomas E. (III). During the conversations, the several members of the family confirmed their interest in art galleries at the University.[57]

On January 11, 1962, Mr. and Mrs. Alanson Donald were luncheon guests of President Elvehjem at the Wisconsin Union. Mrs. (Margot) Donald was the daughter of Mrs. Bryan (Margaret Brittingham) Reid, and the granddaughter of Thomas Evans and Mary Clark Brittingham. The President also invited Mr. Fred and Professor Harry Waisman, whose investigations of mental retardation were discussed with the visitors.[58] Although the initial conversations were about medical research and the Primate Laboratory, there was an agreeable exchange about the campus-wide endorsement of an art gallery building.

The following day, Mr. Fred reported to Baird Brittingham, in Wilmington, that the Donalds were interested in the art gallery project. At the same time, Mr. Fred learned that Baird Brittingham already had asked Mr. Donald Stroud, a Madison attorney, to investigate the legality of pooling a fourth of the funds for galleries from the Brittingham Madison Trust with three fourths from the Brittingham University Trust.[59] Concurrently, the Donalds reviewed the Madison meeting with Mrs. Reid who expressed her pleasure that art galleries could be named for the senior members of the family.

By early February, there was a consensus among Brittingham descendents that one million dollars would be granted for art galleries. Aware that the gift was forthcoming, the author composed a memorandum for President Elvehjem which estimated that the combined costs of gal-

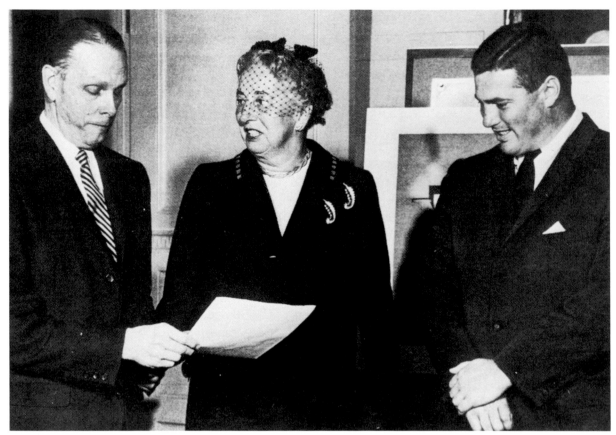

Fig. 21 President Elvehjem accepting the $1,000,000 gift for art galleries from Mrs. Bryan (Margaret Brittingham) Reid and Mr. Baird Brittingham.

Fig. 22 Scale model at the construction site on Murray Street (September 1967).

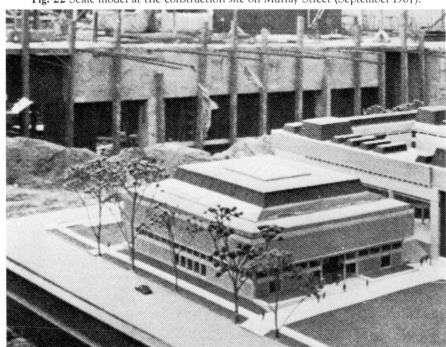

leries and art center would total $3,290.00.[60] The sum seemed obtainable after Mrs. Bryan Reid and Baird Brittingham came to the University and presented the first major funding on May 2, 1962. (Fig. 21) The President responded in a statement of gratitude ". . . how wonderful it is that after seeking aid throughout the nation, we have found it, right here among our friends!"[61] However, Elvehjem was denied the opportunity to lead the project to fulfillment. On July 24, 1962 he was stricken by a fatal heart attack while working in his Bascom Hall office.

Fred Harvey Harrington, who had been Vice-President of Academic Affairs, was named the fourteenth President of the University. In August, the month of his appointment, a faculty Art Center Building Committee was formed to offer advice as architectural plans evolved.[62] And in September, during Harrington's first meeting with the Regents as President, his recommendation that the art center be a memorial to Elvehjem was approved.

Several months earlier, the Brittingham gift had generated the beginnings of a variety of initiatives. An architectural program had to be written and printed, and an architect chosen. The raising of an additional $2,300,000 required the organization of a nation-wide campaign by the University of Wisconsin Foundation.

The Brittingham commitment lent greater urgency to the donation and purchase of fine art works for the collection. There was also a need to alert the University Administration to the increasing costs of operations and staffing while the art center was under construction. Consequently, budget forecasts, prepared as supplements to those of the Department of Art History were forwarded to Edwin Young, Dean of the College of Letters and Science.

A site had to be selected and land acquired before an architect could start preliminary plans or prepare a scale model to be used for a fund-raising campaign. Because the building was intended as a cultural resource for the whole campus and, in some measure for Madison and the State, there was a consensus that the loca-

tion should be near the "Lower Campus." There, an already existing cluster of buildings constituted a threshold to the University for students and the public: the Memorial Union, the Armory (or "Old Red Gym"), the Wisconsin Center, Memorial Library, University Club, and the State Historical Library. But land was scarce, privately owned, and expensive. North of University Avenue, however, between Sterling Court and Murray Street, the Foundation owned some lots and set about to purchase others.[63]

Meanwhile, there was an uneasiness about the chances of commissioning a distinguished architect. The Bureau of Engineering had the power of appointment for state buildings, even when they were privately funded. And architectural commissions had been awarded rather randomly to firms around Wisconsin whose drafting tables happened to be free of work. Fears were allayed, however, on September 18, 1962, when Karel Yasko, the State Architect, announced that the Bureau of Engineering had appointed Harry Weese and Associates of Chicago.[64]

The University of Wisconsin Foundation then faced its greatest task. In addition to the annual program of giving, the goal for the art center alone was $2,300,000—an amount over five times the total gifts for 1961. Thus, when Robert B. Rennebohm, Executive Director, planned the nation-wide campaign in late 1962, the need for architectural renderings, schematic drawings, and a three-dimensional model of the building became urgent.

Even before the appointment of Harry Weese was made, there was a supposition that the site at University and Murray would not allow the Brittingham galleries and the art center spaces to be built as separate units.[65] Furthermore, on September 11, 1962, Mr. Fred learned—in a telephone conversation with Peg Brittingham (Mrs. Thomas E. Brittingham, Jr.)—that the family had no objection to the naming of a unified building in memory of President Elvehjem.[66]

Subsequently, five preliminary designs were drafted by the architects though none satisfied the stipulated requirements. Weese, however, was

an ingenious designer who had developed a great personal interest in the art center. One evening when a small group was assembled in the State Architect's office, Weese led a brain-storming session from which the sixth and basic design of the Elvehjem evolved.[67] (Fig. 22)

Robert Rennebohm announced the campaign in the Madison newspapers in December 1962,[68] even before some of the committees for the major cities and states across the country had been organized.[69] Malcolm Whyte of Milwaukee became the General Chairman with Gordon R. Walker of Racine leading the fund-raising in Wisconsin.[70]

Most campaigns cite one or more large gifts when fund-raising is first announced. The Brittingham subvention of galleries served that purpose for the Elvehjem. During the next ten months the Foundation received $300,000 for the Kohler Art Library, $100,000 for the Mayer Print and Drawing Center, and $175,000 for the Phillips Auditorium. Those gifts provided an impetus for the campaign although in October 1963 the *Wisconsin Alumnus* took some liberties with the facts when it stated that the benefactions had passed the $2,000,000 mark.[71]

During the next two years, other substantial gifts were received. Auditoria, seminar, conference, and lecture rooms, and the main court were named as memorials for members of the donors' families, for colleagues, and alumni classes.[72] (Figs. 23, 24, 25) Concurrently, the contributions of thousands of alumni, friends, foundations, and corporations assured the funding of spaces for exhibition planning and construction, painting conservation, art storage, photographic services, administrative offices, and a museum shop.

Some gifts were evoked through unusual circumstances. Among them was Paige Court (Fig. 26), a memorial to university graduates Del and Winifred Paige. In 1962, Mr. Paige, a partner in the international accounting firm of Ernst and Ernst, was also President of the High Art Museum in Atlanta. He and Mrs. Paige were among the 122 art patrons aboard the fatal flight on June 3 when their plane crashed at the Paris airport.

Soon thereafter, twelve Wisconsin–educated partners of the firm, led by Mr. Newman T. Halvorson of Cleveland, raised the money for Paige Court from their personal resources and a contribution from the Ernst and Ernst Foundation.[73]

By 1964, the contributions to the Elvehjem were diminishing and the enthusiasms of the campaign committees were flagging. A substantial gift was needed to forestall the embarrassment of a prolonged campaign still some distance from its goal. It was at that time that the Wisconsin Alumni Research Foundation considered a large gift that was most exceptional because of its Articles of Incorporation. The Foundation had been established, in 1925, to administer patents on developments by professors, to invest royalties, and to allot funds through the Graduate School for research in the physical and biological sciences.[74]

In 1956, President Harrington, then a professor of American diplomatic history and an aggressive advocate of social science research, was appointed as a representative of those disciplines in President Fred's office. And when Elvehjem became President, in 1958, Harrington was made Vice-President of Academic Affairs.

Consequently, he lent strong support in 1959 when ". . . all funds for research coming to . . . the Graduate School were merged, thus ending the segregation of WARF funds . . . [which then] made possible a significant increase in funds available for the social sciences."[75]

President Harrington looked upon the Wisconsin Alumni Research Foundation as a prospective donor of a large sum to the Elvehjem, although "brick and mortar" for the arts would have had no claim on WARF funds in earlier years. On the other hand, a contribution would honor Conrad Elvehjem who had maintained close ties with WARF as a professor of biochemistry, as a former Dean of the Graduate School, and as President.[76]

The Research Committee of the Graduate School and the Trustees of WARF needed to be convinced that the Elvehjem Art Center would be a locus of research. Therefore, Harrington asked the author to draft a brief that would detail

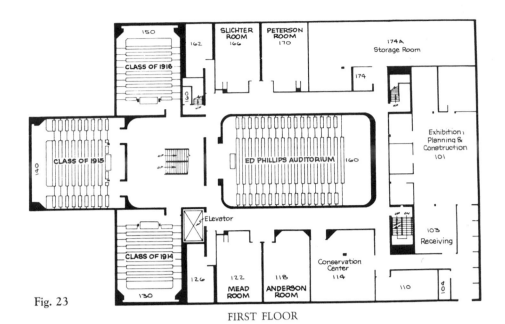

Fig. 23

FIRST FLOOR

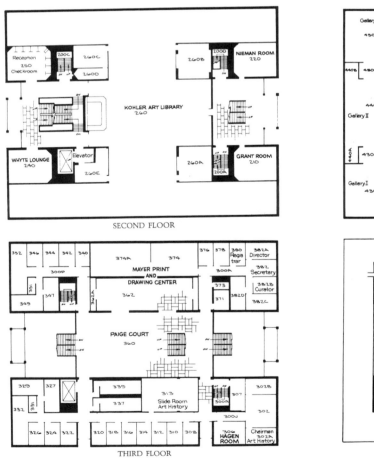

SECOND FLOOR

THIRD FLOOR

Fig. 24

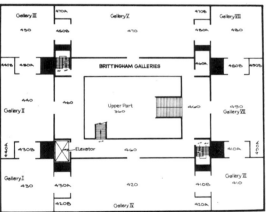

FOURTH FLOOR

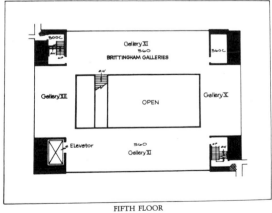

FIFTH FLOOR

Fig. 25

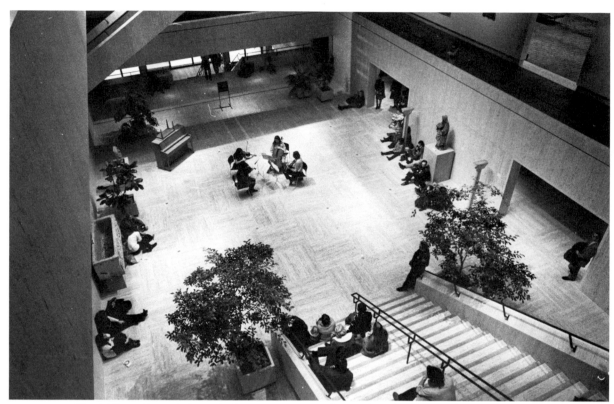

Fig. 26 Paige Court. Rehearsal of a string quartet with an informal audience of student listeners.

Fig. 27 Antoine Bourdelle, *Herakles—The Archer*, 1909, bronze, 80.0×73.7 cm., Gift of Frank G. Hood.

Fig. 28 Unknown Greek, Black-figure *Amphora*, ca. 550 B.C., 38.1 cm. H., Hilldale Fund purchase.

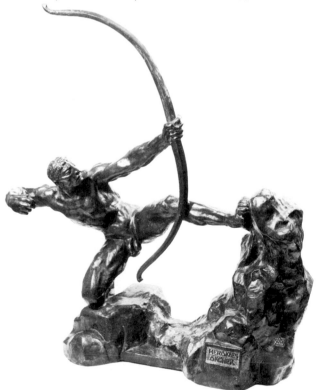

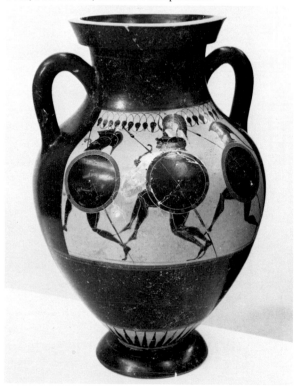

the kinds of research the Elvehjem would foster.[77] In July, Robert Alberty, Dean of the Graduate School advised Harrington that the Research Committee unanimously recommended ". . . that the University ask WARF for support towards the construction of the Elvehjem Art Center . . . [$400,000] to cover part of the research element of that facility." Harrington transmitted the proposal to Donald C. Slichter, President of the Trustees, and soon thereafter, WARF approved the large gift.[78]

It was a very heartening donation even though it came two years after a campaign *Newsletter* of 1962 had speculated that the Art Center ". . . may be designed, constructed, and in operation by 1964."[79] More realistic projections for completion of the building began to fade as various delays plagued the construction for another six years. The Regents did not approve the architectural plans until August 14, 1964.[80] Malcolm

Whyte, General Chairman of the campaign, was unable to announce the completion of the fundraising campaign until one week before groundbreaking ceremonies were scheduled for October 23, 1965.[81] Bids for construction were not received by the Regents until May 1966.[82] And subsequent "slowdowns" and strikes were to delay the completion of the Elvehjem until 1970.

Donations of art and funds for purchases came with more frequency after the announcement of the Brittingham gift in 1962. Moreover, the acquisitions began to exhibit the diversity that was eagerly sought in order to serve university studies in the design arts, history, languages, literature, and other humanistic disciplines.

Late in 1962, Frank Hood of LaCrosse presented three nineteenth and twentieth century sculptures by Rodin, Maillol, and Bourdelle (Fig. 27)—modern French bronzes that were in striking contrast to the Renaissance marbles in the Kress

Fig. 29 Francisco Solimena, *Adoration of the Shepherds*, 1685–1688, oil on canvas, 139.0×181.6 cm., Thomas E. Brittingham Fund purchase.

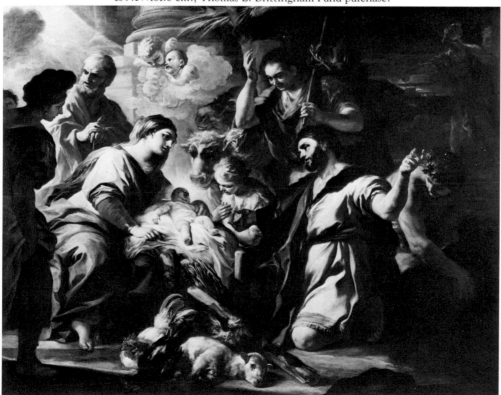

Fig. 30 Giovanni Minelli, *Christ, Man of Sorrows*, ca. 1500, terracotta, 66.0 cm. H., Humanistic Foundation Funds purchase.

Fig. 31 Unknown German, *St. Jerome Removing a Thorn from the Lion's Foot*, ca. 1430–1450, woodcut, 28.3×19.3 cm., Oscar Rennebohm Foundation Fund purchase.

Fig. 32 Gaspard Dughet, *Classical Landscape with Figures by a Lake*, ca. 1660, oil on canvas, 51.2×74.6 cm., University purchase.

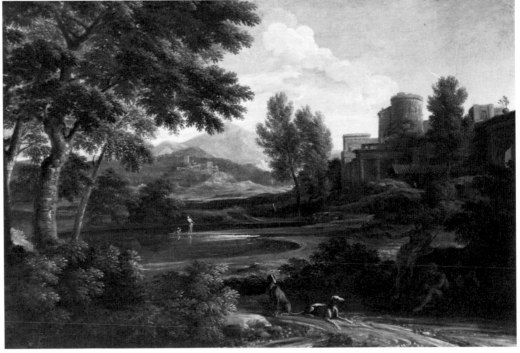

Collection. In 1962 and 1963 Earl Morse, an alumnus, donated sculpture from the subcontinent of India (eleventh to fifteenth centuries), as well as portraits by the British masters John Hoppner and Sir Henry Raeburn.

In 1963, the University purchased its first piece of ancient art with monies from the Hilldale Fund—a black-figure Greek amphora of the mid-sixth century B.C.[83] (Fig. 28) And, late in the year, twenty-eight master etchings and lithographs were added to the print and drawing collection, including works by Jacques Callot, Francisco Goya, James A. McNeill Whistler, and Henri de Toulouse-Lautrec.[84]

Professor Frank Horlbeck of the Department of Art History, when in England each summer, sought works of special value to the Elvehjem. He frequently visited art dealers in the company of Honoria Wormald, who had a perceptive eye for art, and her husband Professor Francis Wormald of the University of London. Their finds led to dozens of purchases, including the black-figured Greek amphora (Fig. 28), a large painting of the *Adoration of the Shepherds* by Francisco Solimena (Fig. 29), and the terracotta of *Christ, Man of Sorrows* by Giovanni Minelli. (Fig. 30)

In 1964, Horlbeck learned that the Colnaghi Gallery, a prominent London dealership, had just acquired from a private source a colored woodcut of the mid-fifteenth century. The print was the only known impression created by an anonymous German artist of *St. Jerome Removing a Thorn from the Lion's Foot.* (Fig. 31) It was a treasure from the earliest period of Western printmaking, an object that any museum or private collector would covet.

William H. Young, professor of political science and a trustee of the Oscar Rennebohm Foundation, had encouraged a donation to the Elvehjem for the purchase of prints and drawings.[85] Luckily, the monies were transferred in time to assure Colnaghi in London that the University would purchase the rare woodcut.

Thus, in 1965, the mid-fifteenth-century print and twenty-four other works obtained with Rennebohm funds were exhibited—along with earlier accessions—in *Six Centuries of Prints and Drawings from the University of Wisconsin Collections,* at the Madison Art Association Galleries in the old Lincoln School.[86]

Between 1958 and 1968 the holdings tripled in number and began to have the artistic diversity that academic departments sought. Sometimes when objects came on the market they had to be purchased quickly or not at all. On several occasions Vice-President Robert L. Clodius found unrestricted funds that were used to guarantee the acquisitions. Such a felicitous arrangement permitted the purchase of a seventeenth-century French landscape found in London by Professor Horlbeck—a *Classical Landscape with Figures by a Lake,* by Gaspar Dughet. (Fig. 32) And the faculty of Scandinavian Studies was delighted when *Vampire,* a major color print by the Norwegian Expressionist Edvard Munch, was bought from a dealer in Boston. (Fig. 33) It was soon complemented by a series of woodcuts by the German Expressionists acquired through the Edna G. Dyar Fund.

In 1968, a series of contemporary American and French prints were given by friends and relatives of Hazel Sinaiko Maryan, an alumna who had been the proprietor of the Little Studio Gallery in Madison. Two years before, Mrs. Maryan had introduced the author to Theodore Landon, a young man from Delavan. Landon had obtained a portfolio of eighty-four engravings by William Hogarth at an auction in Cornwall. He wished to sell the set in order to help fund a personal architectural restoration project in the "Cornish" village of Mineral Point, Wisconsin. Thus, the University acquired almost all of the famous series of prints by the British satirist.

Other periods and places were becoming well represented by the accessions of those years. Jane Werner Watson, alumna and distinguished author of children's books, and her husband Earnest C. Watson, lived in India for some years where he was the scientific attaché assigned to the United States embassy. In 1967, they donated thirty-three Indian miniature paintings for a collection that grew to several hundred through later benefactions.

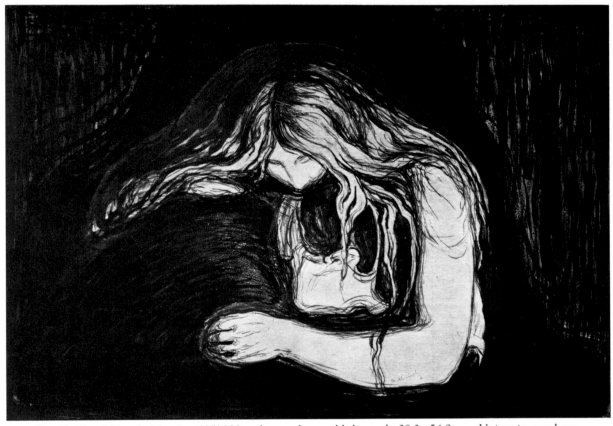

Fig. 33 Edvard Munch, *Vampire*, 1895/1902, color woodcut and lithograph, 38.3×54.9 cm., University purchase.

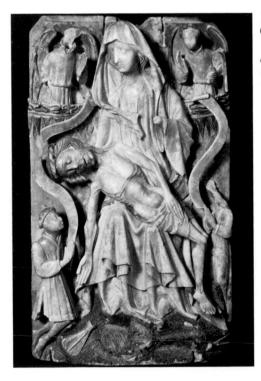

Fig. 34 Unknown English, *Our Lady of Pity (Mary Lamenting the Dead Christ with Two Angels and Two Donors)*, ca.1440–1450, carved alabaster with gilding and polychromy, 43.2×25.1 cm., Max W. Zabel Fund purchase.

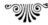

Fig. 35 Millard F. Rogers and the author at the construction site of the Elvehjem Museum of Art, September 1967.

The first two medieval sculptures were acquired with funds willed to the Elvehjem by an alumnus, Max W. Zabel. One is a fifteenth-century Netherlandish *Madonna and Child* in wood by an anonymous sculptor of the Utrecht region. The other, also from the mid-fifteenth century, is an alabaster *Pietà*, carved in high relief by an unknown English master of the Nottingham area. (Fig. 34) Meanwhile, during the late 1960s, many other paintings, prints, pieces of furniture, textiles, and sculptures were acquired and made ready for the opening of the Brittingham and Mayer galleries.

The University of Wisconsin had always been reluctant to place programs directly under the authority of the President's office, favoring an administrative assignment to a college or school. Thus, the Elvehjem was placed in the College of Letters and Science, with the Dean mindful of the museum's campus-wide connections. It became an autonomous unit which was free of the domination of one or another department of fine art—the kind of burden that had often stifled college museums on other campuses.

A year before the ground-breaking ceremonies of 1965, the need to establish an operations and personnel budget for the new institution was recognized. Because a Director for the Elvehjem had not been appointed, for two years the estimates were prepared as supplements to the budget of the Department of Art History. They were then forwarded for the approval of Dean Edwin Young. By 1967, actual budgets could be built by the first Director and submitted to Young's successors, Dean Leon D. Epstein and Dean Stephen C. Kleene, both of whom lent encouragement, as had Young, to the new venture.

In late 1965, the search for a Director of the Elvehjem began. The final stages of construction needed to be followed by a director-in-charge, a staff had to be assembled, and museum policies and practices initiated.[87] In those years recruitment of personnel was less complex than it is today. When Dean Young instructed the author to find several qualified candidates, a canvassing of the country began. After a list of prospective directors was compiled, a few were interviewed at

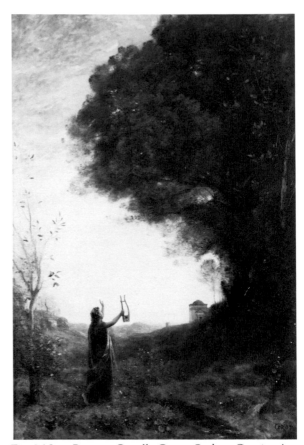

Fig. 36 Jean-Baptiste-Camille Corot, *Orpheus Greeting the Dawn*, 1865, oil on canvas, 200.0×132.1 cm., Gift in Memory of Earl William and Eugenia Brandt Quirk, Class of 1910, by their children.

their museums. One of the prospects, Millard F. Rogers, Jr., Curator of American Art at the Toledo Museum of Art, at first declined to be a candidate.[88] By the summer of 1966, however, he had reconsidered. He visited Madison, found the position attractive, and became the Director of the Elvehjem in May 1967. (Fig. 35)

Rogers lent professionalism to the planning of the new enterprise. Moreover, he was sensitive to the ways in which a museum could be a resource for an academic community. Soon after his arrival, he organized two major committees. One was to advise him on museum policies and planning; the other was to evaluate art works that were being considered for accession to the permanent collection.[89]

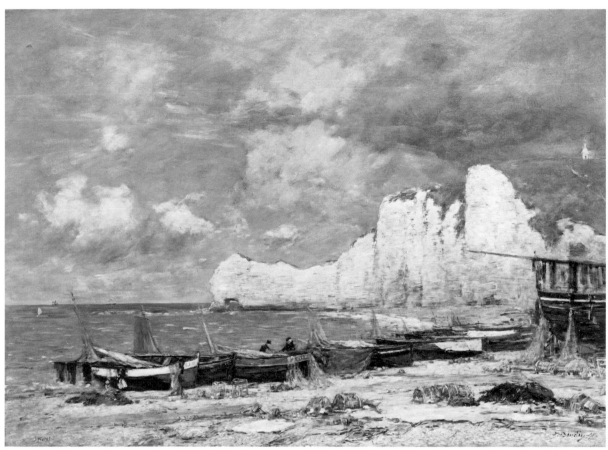

Fig. 37 Eugène Boudin, *Etretat*, 1891, oil on canvas, 78.5×110.5 cm., Gift of Mrs. Frank P. Hixon.

Fig. 38 Karel Appel, *The Clown*, 1954, oil on burlap, 103.2×89.2 cm., Gift of Alexander and Henrietta W. Hollaender.

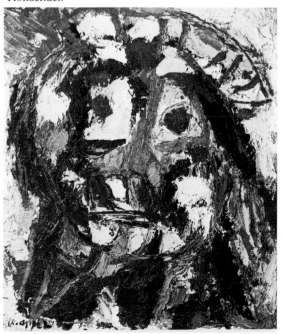

Fig. 39 Charles Burchfield, *Migration of Butterflies by Moonlight,*
1963, watercolor on paper, 82.6×99.1 cm.,
Gift of Mr. and Mrs. Newman T. Halvorson.

Fig. 40 Donors and Guests, Opening Night of the Elvehjem Museum of Art.

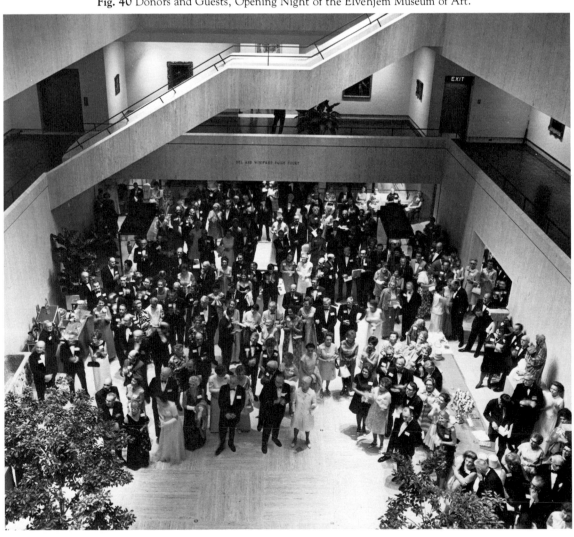

Rogers began to assemble a staff which could carry out the tasks of the next three years.[90] Art objects that were still scattered about the campus had to be retrieved and inspected for their physical condition. Immediate restoration was required for some and they were sent to conservation centers in the country that could treat them with appropriate care. Mock-ups of the unfinished Brittingham and Mayer galleries facilitated the first planning of how the permanent collection should be hung. A search was launched for the paintings and sculptures to be borrowed for an inaugural exhibition of *Nineteenth and Twentieth Century Art from Collections of Alumni and Friends.*[91] The exhibition, a highlight of the opening of the Elvehjem, was a revelation of how many alumni and friends of the University were perceptive collectors of art. Later, a number of the lenders donated the paintings they had lent to the inaugural exhibition, works by Corot, Boudin, Appel and Burchfield. (Figs. 36, 37, 38, 39)

On September 11, 1970, the University of Wisconsin Foundation celebrated its twenty-fifth anniversary with a preview of the Elvehjem. (Figs. 40, 41, 42, 43) A ceremony acknowledged ". . . the generosity of thousands of alumni, individuals, families, corporations, foundations, and other public-spirited groups who made [the art center] possible through their gifts."[92]

It was a joyful evening, although the donors and guests were not free of the frightful recollections that followed the bombing of Sterling Hall—less than three weeks before—with the tragic loss of life, of injuries, and the destruction of research. They were mindful and grateful, as was John Canaday of the *New York Times*, that ". . . the galleries seemed mercifully detached from the campus violence reflected in the scarred buildings nearby . . . [and the Elvehjem had] a reassuring serenity and confidence about it."[93]

The following morning, in a public ceremony, the art center was dedicated to the memory of the thirteenth President when the Foundation presented the building to the University.[94] Edwin Young, then Chancellor, accepted the Elvehjem for the Madison Campus with an affirmation that it ". . . will lift the spirits of us all . . . when spirits need lifting."[95]

Thus, eighty-five years after the loss by fire of the first art gallery, the University received the gift of a splendid museum. The promises of cultural enrichments for the students and State which were made that day have been fulfilled, and more, by the Elvehjem Museum of Art.[96]

Fig. 41 Inaugural Exhibition, Brittingham Gallery IV. Opening Night of the Elvehjem Museum of Art.

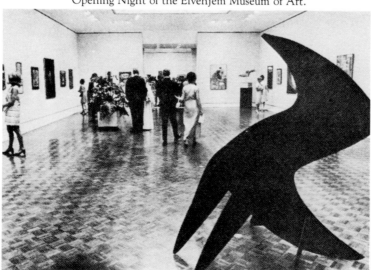

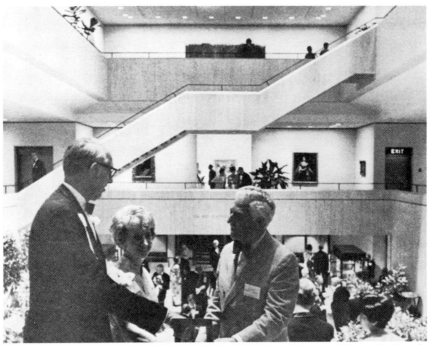

Fig. 42 Paige Court on the opening night of the Elvehjem. Governor Warren P. Knowles greets Elmer and Mrs. (Nanette)Winter.

Fig. 43 Chancellor Edwin Young accepts the Elvehjem Museum of Art for the Madison campus. Seated (from left to right): Robert B. Rennebohm, Mrs. (Jean) Rennebohm, Mrs. (Constance) Elvehjem, Governor Warren P. Knowles.

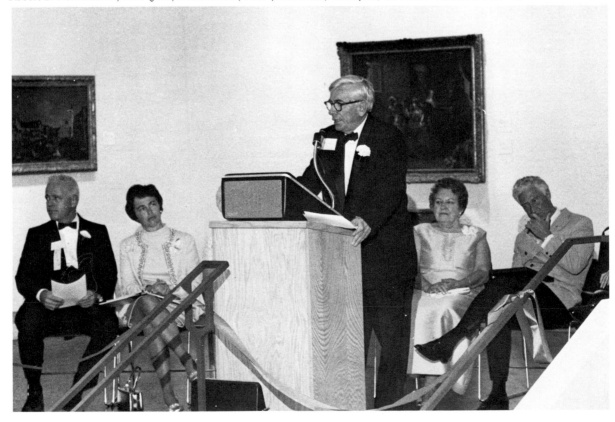

1. The author is grateful to Aaron J. Ihde, Professor Emeritus of Chemistry, who relayed the information that "old" Science Hall was the site of the first art gallery.

2. *Madison Patriot*, 18 October 1876; *Wisconsin State Journal*, 2 December 1884.

The other "valuable works" in the collection, although unidentified, may have been similar to the kinds of paintings and prints owned by Madison residents, e.g.: John Frederick Kensett, *Landscape*, Mrs. Shepard L. (Anna) Sheldon; *The Old Windmill*, a watercolor by John Constable, Charles Noble Gregory; Elihu Vedder, *The Solitary Walk*, Mrs. Lucius (Frances) Fairchild; *Judgment Day* by Gustave Doré, Mrs. William (Anna) Vilas. These and other listings appeared in the *Catalogue of the Madison Art Loan Collection* (1882) and the *Catalogue of the Art Loan Exhibition* (1884).

3. The Thorpes made a fortune in lumbering near Eau Claire. In Madison, they lived in the stone mansion on Gilman Street that later became the Governor's residence. *Madison Daily Democrat*, 17 January 1895.

4. Louise Phelps Kellogg, "Wisconsin at the Centennial," *Wisconsin Magazine of History*, 10.1 (September 1926): 13, note 18.

5. *Madison Daily Democrat*, 17 January 1895. *The State of Wisconsin [etc.] and a Catalogue of the Exhibits at the Centennial at Philadelphia, 1876* (Madison, 1876), 84.

6. *Madison Daily Democrat*, 17 February 1877.

7. *Madison Patriot*, 17 February 1877.

8. *Wisconsin State Journal*, 2 December 1884.

9. *Wisconsin State Journal*, 3 December 1884.

The copy by Mrs. E. R. Curtiss had been removed from "old" Science Hall the day before the fire. It was to be shown in the Art Loan Exhibition at the William Vilas home as part of the annual Grace Church Guild Fair. Mrs. Curtiss, a skillful painter, was the wife of a prominent photographer. John Gruber, "The Curtiss Family: Pioneer Madison Photographers," *The Journal of Historic Madison*, 8.1 (1982–1984): 21–23.

10. The bronze was a replica of the sculpture created for Lincoln's birthplace near Hodgenville, Kentucky. The casting was made at the urging of Richard Lloyd Jones, a student who later became a prominent newspaper publisher. The costs were covered by a donation from Thomas Evans Brittingham, Sr., an alumnus and Regent.

11. The plan was mentioned during the oral history interview of Mr. and Mrs. Horatio B. Hawkins, the latter a sister of Reinsch. State of Wisconsin Historical Society, October 1963.

12. Catalogue of the *Collections of Paintings Owned by Paul S. Reinsch. Exhibition in the State Historical Library Building. September 26 to October 24, 1912.* Madison Art Association (Madison, 1912).

13. Board of Regents Record "H," November 13, 1912, 478. Archives, University of Wisconsin–Madison.

14. *Wisconsin State Journal*, 6 August 1913.

15. Board of Regents Record "I," October 8, 1913, 26, 27. Archives, University of Wisconsin–Madison. Crane's earlier connections with the University were through a daughter, Josephine, whose husband, Harold C. Bradley, had joined the faculty, in 1906, as an assistant professor of physiological chemistry. In 1909, Crane commissioned the Chicago architect, Louis Sullivan, to design and build the landmark house in Madison, now known as the First Bradley House.

16. *Wisconsin State Journal*, 8 October 1913.

17. Board of Regents Record "I," January 21, 1914, 75. Archives, University of Wisconsin–Madison.

18. Board of Regents Record "I," December 17, 1914, 238. Archives, University of Wisconsin–Madison.

19. In 1915 Reinsch wrote to the Secretary of the Regents that eight (Crane) paintings [which he had never delivered to the University] had been lost in Chicago and that he would substitute thirteen others. In November 1919, Reinsch removed three (Crane) paintings and offered two new ones in compensation. The Registrar's files, Elvehjem Museum of Art.

20. Two years after Reinhardt died, in 1921, George I. Haight led the solicitations from alumni that helped to fund the gift. However, no one seems to have contemplated where on campus a painting of such enormous size might be exhibited. In 1986, during a conversation with the author, Porter Butts recalled that after the Memorial Union was built, Haight proposed that the altarpiece be hung on the back wall of the stage in Great Hall.

21. Janet S. Ela, *The Madison Art Association 1901–1951* (Madison, 1951), 44, 73, 74.

22. By 1935 the Wisconsin Union had acquired enough paintings by purchase from traveling shows to warrant an exhibition entitled "The Permanent Collection of the Wisconsin Union." Inexplicably, six works from the Crane collection were in the exhibition. Catalogue of the exhibition, 1935. In 1985, over 750 art works were listed in "The Wisconsin Union Art Collection: A Catalogue Listing;" published in conjunction with a brochure, Jody Schmitz, *A Reflection of Time: The Wisconsin Union Art Collection* (Madison, 1985).

23. It is not clear to whom the memorandum was sent. A copy is in the files of the Registrar, Elvehjem Museum of Art.

24. Joseph E. Davies to Philip F. La Follette, March 9, 1937. A copy is in the files of the Registrar, Elvehjem Museum of Art.

25. Joseph E. Davies to Clarence A. Dykstra, February 10, 1938. A copy is in the files of the Registrar, Elvehjem Museum of Art.

26. *Ibid.*

27. Catalogue of *The Joseph E. Davies Collection of Russian Paintings and Icons Presented to the University of Wisconsin* (New York, 1938).

28. Clarence A. Dykstra to Joseph E. Davies, June 8, 1938. A copy is in the files of the Registrar, Elvehjem Museum of Art.

29. The room was for the storage of equipment used for productions in the University [Bascom] Theater, now an auditorium, Room 272.

30. Hagen was a Carl Schurz Visiting Professor from the University of Göttingen in 1924. In the following year he accepted an appointment from Wisconsin and established the Department of Art History.

31. Hubbard, a Canadian, received a Ph.D. from Wisconsin and later became Curator of Painting at the National Gallery of Canada in Ottawa.

32. Reports and correspondence on those matters from 1942 to 1948 are in the files of the Registrar, Elvehjem Museum of Art.

33. Archives, University of Wisconsin–Madison. The author is grateful to Anne Biebel, Specialist, University of Wisconsin Press, who brought the renderings to his attention.

34. Two features of *The Proposed New Mall* were completed in 1958. They were the Wisconsin Center building and the fountain between the two libraries on the Lower Campus. The latter was donated by the principal advocate of the plan, William J. Hagenah, an alumnus.

35. Curry's appointment in the Department of Rural Sociology was supported by the Brittingham Trust. His role was to encourage art in the rural areas of Wisconsin.

36. The committee included Professors Oskar F. L. Hagen, Chairman, John Barton (Rural Sociology), Frederick Logan (Art Education), James Watrous (Art History), and Madison friends of Curry, Mrs. Adolph (Eugenia) Bolz, and Dr. Wellwood Nesbit.

37. Ingraham's interest in an art museum grew during his deanship (1942–1961). After the Elvehjem Museum of Art opened, he and his wife, a talented etcher, endowed the Mark H. and Katherine Ely Ingraham Fund for the purchase of American prints.

38. Between 1948 and 1967, nineteen graduate students served as curatorial assistants. All became museum or art history professionals: Ben Bassham, Colin Cameron, Joanne (Saari) Face, Constance Ford (Dowling), Wayne Halverson, Margaret Huber, Ellen Johnston, Arnold Lewis, Beth I. Lewis, Josephine Long, Cindy Marriot, Judith Mattson, Kathleen (Elberts) McCullough, Doris (De Vries) Parker, Roslyn Rensch, Merrill Rueppel, Pamela Self, James Slayman, and Maïda (McIlroy) Wedell.

39. The new space for art storage had been book storage for the Library's Bascom Reading Room. It was vacated after the books were moved to a large Quonset hut on the Lower Campus in 1947. "Lorelle Wolf," *Library News* 3 (September, 1956).

40. James Watrous to President E. B. Fred, May 15, 1958. The letter reviewed the storage conditions and occasional exhibition of selected paintings from the Davies collection. Copy in the files of the Registrar, Elvehjem Museum of Art.

41. The courses in art history were: *Master Prints and Printmakers of the Western World; Modern Prints and Printmakers; The History of Satire in Prints.* Studio courses were developed in all of the important print media, including woodcut, wood-engraving, etching, lithography, and serigraphy.

42. Hawley, a resident of Dane County and Delray Beach, Florida, also gave two paintings. One, *Venice and Grand Canal* (1888) by Charles Gifford Dyer, is an excellent example of American impressionist painting. Board of Regents Record, "Gifts (rr)," October 25, 1952, 9. In 1954, Miss Cecilia Hawley donated nine more prints to the Hawley collection. Board of Regents Record, "Gifts (ee)," September 25, 1954, 7. Archives, University of Wisconsin–Madison.

43. Kiekofer, as quoted by Jonathan W. Curvin in "The University and the Arts," *The University of Wisconsin: One Hundred and Twenty Five Years.* Edited by Allan G. Bogue and Robert Taylor (Madison, 1975), 240.

44. *Wisconsin Alumnus* 53.6 (March 1952): 12.

45. Plans to remodel Washburn Observatory were abandoned by the Wisconsin Alumni Association in June, 1959. A new Alumni House was completed in 1967 on a lake shore site next to the Wisconsin Center (1958). Washburn Observatory (1877) was assigned to the Institute for Research in the Humanities.

46. K. Louise Henning of the library staff assisted exhibitors. Unofficial advisors for the gallery were Gibson Byrd, Warrington Colescott, and Frederick Logan, professors of art. Notices of the exhibitions were published in *Library News.*

47. In 1962, the Department of Art History presented "Satirical Prints." The exhibition included works by Hogarth, Gillray, Cruikshank and others which had been given to the University by the heirs of Professor William S. Marshall in 1953, and by Professor Harold E. Kubly in 1955.

48. The Humanistic Foundation was established by a bequest of Howard L. Smith, Professor of Law, who died in 1941.

49. Cummings was a major collector of ancient Peruvian and modern European art. Three paintings came to the University by way of his acquaintance with Aaron Bohrod, American painter, who was the successor to John Steuart Curry as Artist-in-Residence.

50. For a few years Rojtman was President of the J. I. Case Co. of Racine. The first contact by the University was made when Vice-President Ira L. Baldwin and the author were invited to the Rojtmans' art-filled home. His background and reasons for assembling a large art collection were not fully explained. However, while the Rojtmans resided in Wisconsin they gave the University fifteen paintings in two groups and a gift of $10,000 to bring distinguished British and European art historians to the campus.

51. Lewis received a Ph.D. from Wisconsin in 1962 and later became Professor of Art History at the College of Wooster.

52. Despite extensive correspondence between Davies, President Fred, and John Ritchie, Dean of the Law School (1953–1957), neither the painting or its title was received by the University.

53. *Wisconsin Alumnus* 59.11 (March 1958): 6.

54. Professional craftsmen at the Mitchell Model Co. of St. Joseph, Michigan, were the builders. *Department of Art History Newsletter* 3.2 (March 1958): 1.

55. Minutes of the Administrative Committee, July 22, 1958. "VIII. Priority List for the Request of Wisconsin Foundation Funds." Archives, University of Wisconsin–Madison.

56. A large altarpiece by Defendente Ferrari, *Madonna and Child Enthroned with Saints and Angels,* was being restored in 1961 and arrived too late for the exhibition at the Wisconsin Union.

57. Memorandum of a long distance telephone conversation, December 20, 1961; E. B. Fred to members of the Brittingham family. Archives, University of Wisconsin–Madison.

58. Others attending the luncheon were A. W. Peterson, Vice-President of Business and Finance, George Field, Assistant to the President, and Professor Philip Cohen of the Department of Physiological Chemistry.

59. Memorandum of a long distance telephone conversation, January 12, 1962; E. B. Fred to Baird Brittingham. Archives, University of Wisconsin–Madison.

60. In the memorandum of April 10, 1962, the author informed the President that Kurt Wendt, Dean of Engineering and Chairman of the Campus Planning and Construction Committee, had independently estimated the project cost between $3,200,000 and $3,500,000. Archives, University of Wisconsin–Madison.

61. Statement of President C. A. Elvehjem, May 2, 1962. Archives, University of Wisconsin–Madison. The gift was accepted by the Regents on May 4, 1962.

62. Members of the committee were: Porter Butts, Director of the Wisconsin Union; Professor Gibson Byrd, Department of Art; Leo Jakobson, Institutional Planner; Donald Sites, Architectural Planning and Construction; and Professor James Watrous, Department of Art History (Chairman). The committee held few formal meetings because a majority—Jakobson, Sites, and the author (a faculty representative on the Campus Planning and Construction Committee for several years)—were continually involved in design decisions as they arose.

63. Some of the land purchases were expedited by a short term "loan" of $200,000 from the University's Kemper K. Knapp Bequest and the Anonymous Fund.

64. The choice of architect was considered crucial because many alumni and friends expected that the Elvehjem would be a symbol of how private benefaction could lend architectural and cultural distinction to the campus. Dean Kurt Wendt, Chairman of the Campus Planning Committee, favored the selection of a nationally known firm, such as Skidmore, Owings, and Merrill. Leo Jakobson, Institutional Planner, was an admirer of the work of Harry Weese. And the author, who knew the State Architect through membership on several committees, including the Campus Planning Committee, urged Yasko, in conversations and by letter, to commission a distinguished American architect.

65. An objection to the unified building threatened delays in the planning and the campaign. Mr. Malcolm Whyte, a Milwaukee attorney and the General Chairman of the fund-raising campaign, had at first been an advocate of a unified building, then later argued for a complex of two units. When the plans were presented for informational purposes to the Board of Directors of the Foundation, Whyte argued testily for scrapping them. Delays were averted when Mr. Irwin Maier, Chairman of the Board of the Journal Company in Milwaukee and Associate Chairman of the campaign, reminded Whyte and others that the Foundation's role was to support University-recommended projects, not revise them.

66. Memorandum of the telephone conversation, E. B. Fred to Peg Brittingham; September 11, 1962. Archives, University of Wisconsin–Madison.

67. At the session were Harry Weese and an associate architect; James Galbraith, soon to be appointed the successor to Karel Yasko as State Architect; William Kinney of Campus Planning and Construction; and the author as representative of the various "clients."

68. *The Capital Times,* 13 December 1962; *Wisconsin State Journal,* 14 December 1962.

69. In 1965, the officers and committees of the campaign were published in the *Elvehjem Art Center News:*

Campaign Organization
General Chairman Malcolm K. Whyte '12, Milwaukee.
Associate Chairman Irwin Maier '21, Milwaukee.
Associate Chairman Howard I. Potter '16, Chicago.

Arizona—Martin R. Paulsen '23, Tucson.
California (Northern)—Emmett G. Solomon '31, San Francisco.
California (Southern)—Robert L. Willding '42, Los Angeles.
Chicago—Harold G. Laun '27.
Colorado—Karl R. Wendt '29, Broomfield.
District of Columbia—Philip K. Robinson '15.
Florida—D. Richard Mead '22, Miami.
Iowa & Nebraska—William A. Klinger '10, Sioux City.
Kentucky—Harold J. Utter '27, Lexington.
Michigan—Anthony G. DeLorenzo '36, Detroit.
Minnesota & Dakotas—John Sarles '23, Minneapolis.
Missouri & Kansas—Raymond E. Rowland '25, St. Louis.
New England—Ora C. Roehl '28, Boston.
New York (Eastern)—C. Guy Suits '27, Schenectedy.
New York (Western)—Robert A. Ackerman '51, Rochester.
New York City—Whitney N. Seymour '20.
Ohio—Newman T. Halvorson '30, Cleveland.
Oregon—Willard C. Schwenn '39, Hillsboro.
Pennsylvania (Eastern)—Charles H. Carpenter '20, Moorestown, New Jersey; William H. Balderston '19, Meadowbrook, Pennsylvania.
Pennsylvania (Western)—Thomas N. Herreid '24, Pittsburgh.
Tennessee (Eastern)—Joseph T. Mengel '17, Knoxville.
Texas—Ralph E. Davis '06, James E. Ivins '35, Houston.
Washington—Z. T. Szatrowski '49, Seattle.
West Virginia—C. B. Christianson '22, Wheeling.
Wisconsin—Gordon R. Walker '26, Racine.
Madison—Lawrence J. Larson '32.
Milwaukee—Allen M. Slichter '18; Joseph A. Cutler '09.
Hong Kong—Stephen Y. N. Tse '55.
Korea—Lt. Col. Gordon J. Duquemin '45, Seoul.
Philippines—Col. Vernon W. Froehlich '49, Manila.
Thailand—Limin Lamsam '48, Bangkok.
UW Faculty—E. B. Fred and Mark H. Ingraham.

70. Walker, a former Regent and President of the Foundation, became the first Chairman of the Elvehjem Museum of Art Council. With his wife Susan, he provided funds for several acquisitions, including the George Bellows painting, *Approach to the Bridge at Night* (1913).

71. *Wisconsin Alumnus* 65.1 (October 1963): 11.

72.

Space	Memorial	Benefactors
Kohler Art Library	Walter J. Kohler, Sr., Ms. Evangeline, Marie C. and Lillian B. Kohler	Herbert V. Kohler, Sr., the Kohler Co., the Kohler Foundation.
Mayer Print and Drawing Gallery and Center	Oscar F. and Louise Greiner Mayer	The Oscar Mayer Foundation.
Paige Court	Del and Winifred Paige	Ernst and Ernst Foundation, and twelve alumni who were partners in the firm.
Phillips Auditorium	Ed Phillips	Mr. and Mrs. Lewis E. Phillips.
Class of 1914 Auditorium	50th Anniversary Class Gift	Class of 1914.
Class of 1915 Auditorium	50th Anniversary Class Gift	Class of 1915.
Class of 1916 Auditorium	50th Anniversary Class Gift	Class of 1916.
Whyte Lounge	Malcolm K. Whyte	University of Wisconsin Foundation.
Hagen Conference Room	Professor Oskar F. L. Hagen	University of Wisconsin Foundation.
Grant Lecture Room	Harry J. Grant	Harry J. Grant Foundation and Mr. and Mrs. Donald B. Abert.
Neiman Lecture Room	Lucius W. Nieman	Ms. Faye McBeath.
Slichter Seminar Room	Charles Sumner and Mary Byrne Slichter	Allen M. and Donald C. Slichter.
Anderson Lecture Room	Louis Royal Anderson	Mr. and Mrs. LeRoy A. Peterson.
Peterson Seminar Room	Sarah Colossino Peterson	Arthur F. Peterson.
Mead Seminar Room	George W. Mead	Mrs. Emily Mead Baldwin Bell and Stanton W. Mead.

73. Newman and Virginia Halvorson were supporters of the Elvehjem Museum before and after its completion. He was the Chairman of the fund-raising campaign for the Ohio area and, in 1972, when the Elvehjem Museum of Art Council was formed, became an alumni member. Before the Elvehjem opened, Mr. and Mrs. Halvorson gave a seventeenth-century marble relief by François Duquesnoy, *Sacred and Profane Love.* For the Inaugural Exhibition (1970) they lent *Migration of Butterflies by Moonlight* by Charles Burchfield (Fig. 39), a watercolor they subsequently gave to the Elvehjem in addition to other gifts in kind.

74. The potentials for commercial development and royalty income from the research on vitamin D by Professor Harry Steenbock encouraged the establishment of the Wisconsin Alumni Research Foundation (WARF). Nine alumni contributed $100 each as capital for the venture. George I. Haight was the first President of the Board of Trustees (1926–1955). *Wisconsin Alumni Research Foundation Summary Report* (Madison 1986), 4, 5, 28.

75. William H. Sewell, "Development of Research in the Social Sciences, 1949–1974," in *The University of Wisconsin; One Hundred and Twenty-five Years.* Edited by Allan G. Bogue and Robert Taylor (Madison 1975), 219.

76. Other factors may have helped the proposal. Charles S. Slichter, Dean of the Graduate School in 1925, had encouraged the founding of WARF. Two of his sons, Allen and Donald, the latter the President of the Board of Trustees in 1964, had donated funds in memory of the father for a seminar/conference room at the Elvehjem. Furthermore, Thomas E. Brittingham, Jr., whose family trusts had guaranteed the galleries, had been President of the Trustees from 1955 to 1960.

77. On April 27, 1964, the author sent the document to Harrington. It described seven areas of research to which the Elvehjem would lend support. Archives, University of Wisconsin–Madison.

78. Fred Harvey Harrington to Donald C. Slichter, July 14, 1964. Archives, University of Wisconsin–Madison. The transfer of monies was not necessary for another three years. Fred Harvey Harrington to William Kellett, June 13, 1967. Archives, University of Wisconsin–Madison.

79. *Elvehjem Art Center Newsletter* (December 1962), 3.

80. *Wisconsin State Journal,* 15 August 1964.

81. Ground-breaking ceremonies were scheduled the same day for Alumni House at 650 North Lake Street.

82. The Elvehjem Art Center and the Humanities Building were bid as a single project, although the latter was a classroom building funded by the legislature. The Corbetta Construction Company of Des Plaines, Illinois, was awarded the general contract. Board of Regents Records, Exhibit "E," May 6, 1966.

83. The Hilldale Fund receives monies for the exclusive use of the University from Kelab, Inc., a corporation which administers the leases and royalties of the Hilldale shopping mall. It was built on a parcel of land retained when the University Farms were subdivided and sold according to a master plan of 1955.

84. Monies for the purchases came from the Oskar F. L. Hagen Memorial Fund, the Humanistic Foundation, and a gift of the Class of 1963.

85. *The Oscar Rennebohm Foundation Collection of Prints and Drawings.* Catalogue of the collection in the Elvehjem Museum of Art (Madison, s.a.). Oscar Rennebohm, an alumnus and successful business man, was Governor of Wisconsin and a Regent of the University.

86. *Six Centuries of Prints and Drawings from the University of Wisconsin Collections* (Madison, 1965). Catalogue of the exhibition at the Madison Art Association galleries, November 21 to December 11, 1965.

87. Gordon D. Orr, Jr., an Assistant State Architect, was appointed Campus Architect in 1965. From then on, he followed the construction of the Elvehjem with a personal, as well as a professional, interest.

88. Millard F. Rogers, Jr., received a B.A. from Michigan State University, a M.A. in museum training at the University of Michigan, and a Fellowship at the Victoria and Albert Museum, London. At the Toledo Museum of Art, Rogers was Assistant to the Director, Assistant Curator, and Curator of American Art.

89. Elvehjem Art Center Policy and Planning Committee: R. Ward Bissel (Art History), D. Gibson Byrd (Art), Leon D. Epstein Dean (L. and S.), Harald F. Naess (Scandinavian Studies), Millard F. Rogers, Jr. (Chairman), James Watrous (Art History). Elvehjem Art Center Accessions Committee: Warrington Colescott (Art), Mildred Gahrsen (Related Arts), Frank R. Horlbeck (Art History), Millard F. Rogers, Jr. (Chairman), John Wilde (Art).

90. The staff at the time of the opening was: Millard F. Rogers, Jr., Director; Arthur R. Blumenthal, Curator; John Hopkins, Registrar; William C. Bunce, Chief, Kohler Art Library; K. Louise Henning, Assistant Librarian; Ruth Jackson, Administrative Secretary; Law Watkins, Project Specialist; Henry Behrnd, Gallery Technician; John A. Kehr, Supervisor of Guards.

91. *Inaugural Exhibition: 19th & 20th Century Art from Collections of Alumni & Friends.* Foreword by Millard F. Rogers, Jr.; Introduction by Arthur R. Blumenthal (Madison, 1970). Catalogue of the exhibition at the Elvehjem Art Center, September 11 to November 8, 1970.

92. *Elvehjem Art Center, Dedication Brochure* and *Honor Roll.* Published by the University of Wisconsin Foundation (Madison, September 12, 1970).

93. John Canady, "A Bit of Good News from Madison?" *New York Times*, 13 September 1970; D 29.

94. Robert B. Rennebohm, Executive Director of the University of Wisconsin Foundation, was the Master of Ceremonies. Lester S. Clemons, President of the Foundation, presented the building to the University. Chancellor Edwin Young accepted it for the Madison Campus; President Fred Harvey Harrington for the University; Bernard C. Ziegler for the Regents; and Governor Warren P. Knowles for the State of Wisconsin.

95. Rosemary Kendrick, "Elvehjem Art Center Hailed as 'Building to Lift Spirits,' " *The Capital Times*, 12 September 1970.

96. The story of the first seven years of the museum is included in the article by Joyce Bartell, "Elvehjem—Art for All Wisconsin," *Wisconsin Trails* 18.4 (1977): 14–18. Joyce Jaeger Bartell has been a member of the Elvehjem Museum of Art Council since it was formed in 1972, and was its Chairman from 1977 to 1979.

Design: Christos M. Theo

Elvehjem Museum of Art
800 University Avenue
Madison, Wisconsin 53706